How to paint with
Brush-tipped
felt pens

Richard Bolton

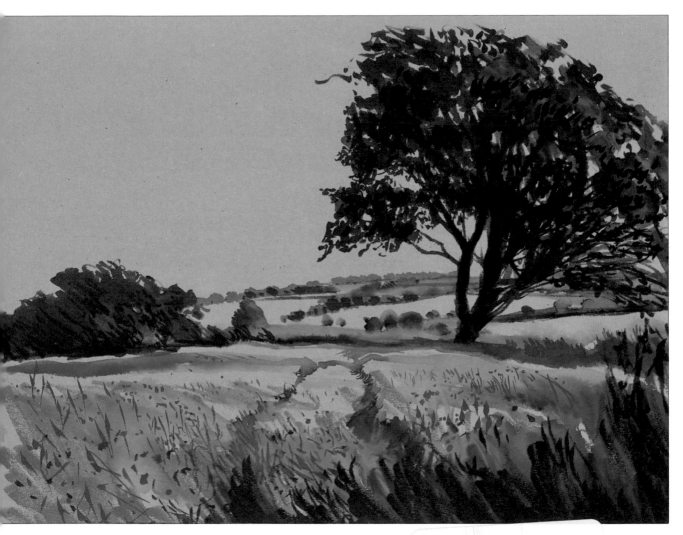

SEARCH PRESS

First published in Great Britain 1996

Search Press Limited
Wellwood, North Farm Road,
Tunbridge Wells, Kent TN2 3DR

ISBN 0 85532 801 0

TITLE PAGE
*Working on a toned paper can be useful in controlling the
colours in a drawing, helping to unite them by imparting a
general hue to the picture. It can also reduce the amount of
pen work required.*
*For this drawing of a cornfield, I selected a deep flesh-
coloured paper, which gave a warm backdrop to the scene. I
painted the picture quickly, adding water to the background
hedgerows to soften the edges and set the background
slightly out of focus. I then treated the foreground
vigorously, using splashes of yellow and mauve to depict
the tractor tracks through the corn. Specks and dabs of
colour describe the mass of cornheads and weeds, but I have
made no attempt to define this area in any detail, preferring
to retain the freshness and fluid nature of the brushstrokes.
The tree on the right has been drawn in with greens, blue
and brown, but it is so dark that it has almost become a
silhouette.*

Original size: 230 x 300mm (9 x 12in).

OPPOSITE
*In this picture of evening shadows, I painted some ordinary
bleach into the trees on the left to produce these white lines.*
Original size: 230 x 400mm (9 x 16in).

Printed in Spain by Elkar S. Coop, Bilbao 48012

Contents

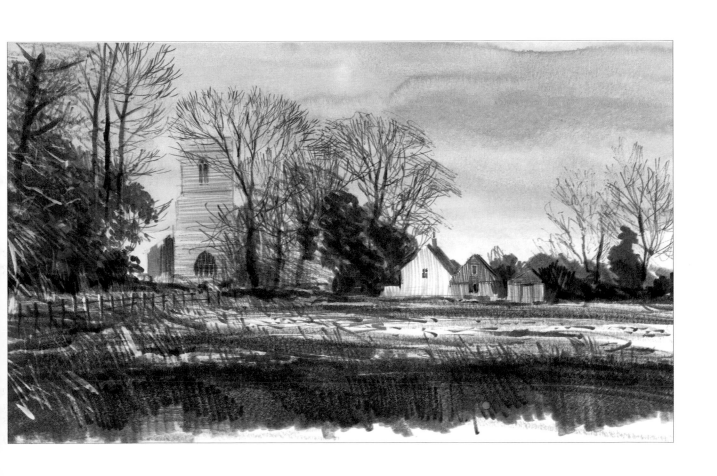

Introduction

Before I first used brush pens, I had in mind the lurid colour range and crude inflexible tip that we usually associate with felt-tip pens. They have been connected with the children's end of the market for so long that they have developed an image of being 'cheap and nasty'. I was pleasantly surprised to find a medium that was not a gimmick but a useful new addition to the range of artists' products.

The range of brush pens I use comprises a hundred colours. As well as the usual bright colours associated with felt-tip pens, the range also includes subtle hues and many 'dull' but subtle colours which, although not eye-catching, are essential for conveying some of the moody colour schemes we so often find in landscapes.

Brush pens can be combined with water for a range of fluid effects. All the colours are dyes and have a high staining capacity, and once on the paper are difficult to remove. This makes some familiar watercolour techniques difficult, such as 'lifting out', where an area of colour can be teased with a wet brush and lifted out with a tissue.

However, they are flexible, versatile, fun to use and generally a worthwhile addition to any artist's repertoire.

About brush-tipped felt pens

The name 'brush pen' aptly describes the drawing tip of these pens. The tip, made from a sort of felt, looks like a tapering watercolour brush and is very soft and flexible, capable of anything from fine work to swelling thick strokes, giving the user a great deal of expressive control. There are a number of different brands on the market and they all perform in much the same way except for the very cheap ones for the children's market, which are rather less flexible. I use the Mars Graphic 3000 range by Staedtler. These have the added bonus of incorporating a fine-line marker on the other end of the pen, so that they can be reversed for additional techniques like cross-hatching and more rigid line work.

To experiment with brush pens, you do not need to buy the full range. There are specially made starter packs which contain small numbers of pens, carefully selected to give a limited-range palette; or alternatively you can buy the pens individually in the colours of your choice. Much good work can be achieved using a limited range of only a few colours, and you can add further colours to this as required. Working in the field, this can be ideal, as you can simply put pens in your pocket, with no need to worry that they may leak. Just remember to replace the caps, or they will dry out.

Choosing paper

You can use brush pens on all sorts of surfaces, and the choice of paper can have a strong influence on the style of drawing. If you are going to use water, stretching may be necessary, although this can often be avoided by using card or thick paper. Hard, smooth-surfaced papers can be worked on swiftly, but soft, absorbent surfaces tend to soak up the inks, which can make building up heavy areas of tone hard work. This makes the workmanship become more laboured; also, when wet, the paper becomes very fragile, so there is also the danger of damaging the surface. Ideally, where a lot of wetting and scrubbing-in of colours will be going on it is best to select a watercolour paper which will be able to withstand this treatment.

It is always a good idea to experiment first to make the best choice, as the type of paper you choose really does make a big difference to a drawing. The only kind that is really unsuitable is cheap paper on which the ink will 'bleed' unpleasantly.

Textured paper

To make the best use of textured paper, I use the brush pen on its side, so that the flat side of the brush skims over the rough surface, applying ink only to the textured surface. By this means the drawing develops a grainy quality. I have avoided using water with this kind of paper as this would tend to lose the speckled quality.

Card

A lot of my work is done on smooth card. This works well, used with or without the application of water, and of course I do not need to stretch it. When applying water to colours, as shown in the demonstrations on pages 27 and 30, it is best to avoid overworking with the brush and to allow the colours to blend together freely.

This picture of a terracotta figurine was drawn on smooth-surfaced paper and demonstrates an imaginative use of colour. The background of yellows and browns contrasts strikingly with the warm colours of the figurine. I modelled the form using first the broad side of the pen and then the fine tip.

Original size: 255 x 190mm (10 x 7½in).

Board Tinted card Cartridge Textured paper

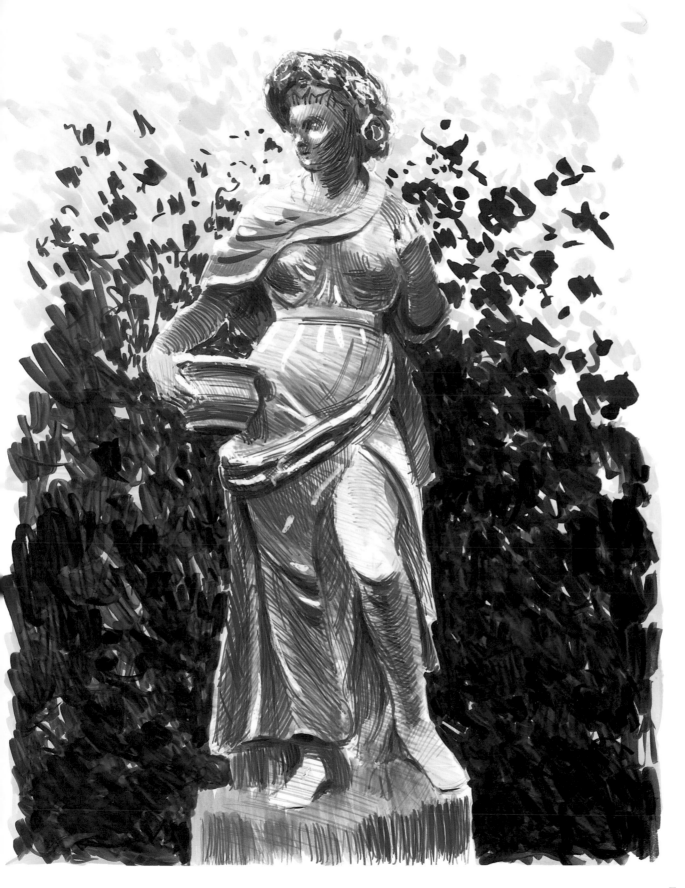

Experimenting with brush pens

Many people make their initial experiments with a single black brush pen before committing themselves to buying a set of coloured pens. This way first-time users can quickly assess the handling qualities without any great expense.

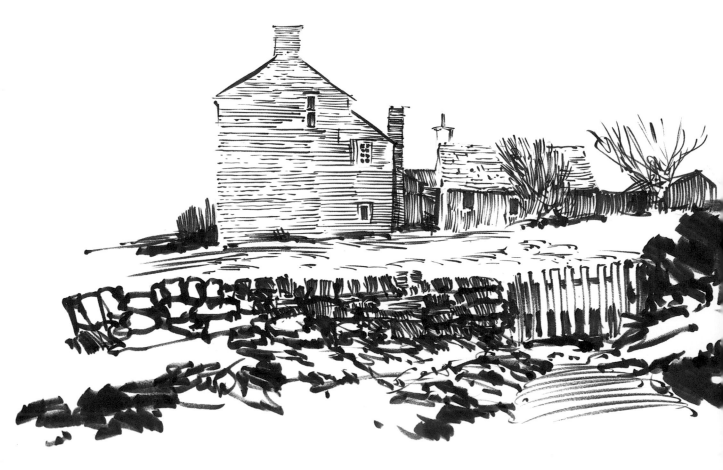

Line drawing

You can use brush pens as simple drawing tools. Here their character is illustrated by a drawing of some geese. You can see how the line work has character, swelling out thickly in some places while thinning out in others.

In the drawing of old farm buildings below, the subject gets a bit more involved and the value of the drawing tip is more apparent.

The background scene of buildings I have tried to draw with restraint, holding the pen lightly so that just the tip passes over the paper in order to keep the line work delicate. This takes a bit of skill, as it is easy to drop the tip down a little and thus create thicker lines.

In the foreground I have worked quickly to introduce a lively quality to the line work. The thickness of the line enables me to block in dark areas speedily.

To create really thick lines, I lean the brush pen over on its side and sweep the side of the pen tip across the paper, as demonstrated in this sketch of a rowing boat on the sand. By doing this, an impression of sand can be swiftly given by brushing the tip backwards and forwards across the paper.

For the beginner, I would recommend starting with at least three pens. This enables the artist to mix tones or colour on the paper and to get some idea of the pens' potential. One limited range I like is black and two different greys, as this gives a useful range of tones. In a landscape this could give you foreground, middle ground and distance, and in figurative work you would also be able to make some subtle differences in tone.

Another useful mix is burnt umber, burnt sienna and raw sienna, to which, if possible, I would add a grey.

The coloured tops to all these pens are usually a poor indication to the actual colour they contain, so ask if you can test the actual colour in the shop before you buy.

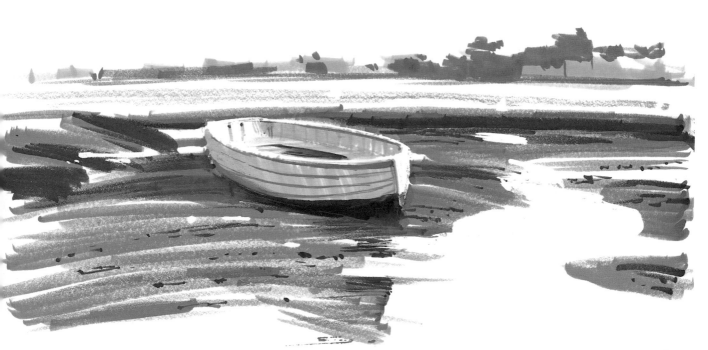

Lakeside

A range of greys can be very useful. This drawing uses three: the lightest grey for the hills in the background and the darkest for picking out the shadows round the tree. You can see how useful these pens can be when you are drawing outside and want to keep your materials to a minimum.

Original size: 175 x 290mm (7 x 11½in).

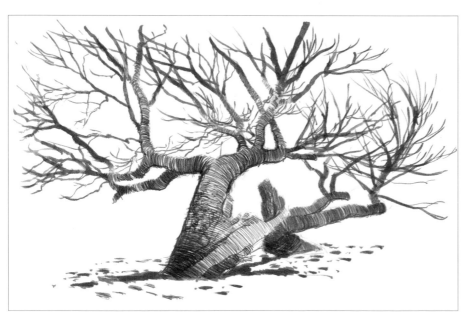

Stunted tree

Shape is given to the branches and trunk of the tree by describing the contours with curved sweeps of the pen. Being left-handed, I can draw the curves leaning to the right more easily than those that lean to the left.

Original size: 175 x 280mm (7 x 11in).

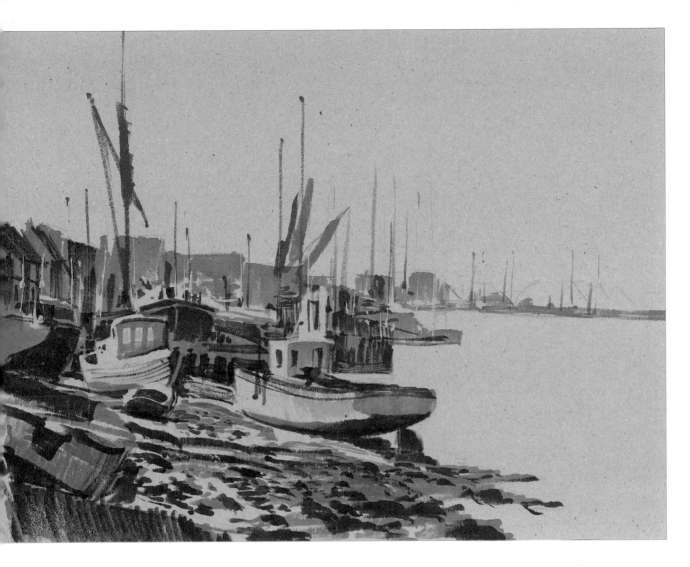

Boats at low tide

Again I am using a limited range of colours. The drawing relies heavily on greys, but I have also introduced some other colours – browns and a little light blue on the sides of the boats. I drew this on a green-grey paper to correspond with a rather dull day.

Original size: 230 x 290mm (9 x 11½in).

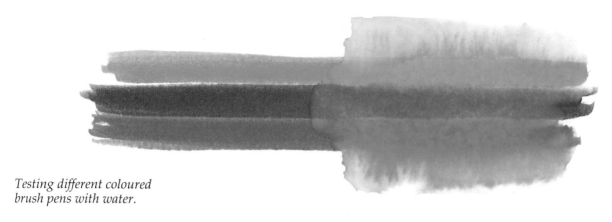

Testing different coloured brush pens with water.

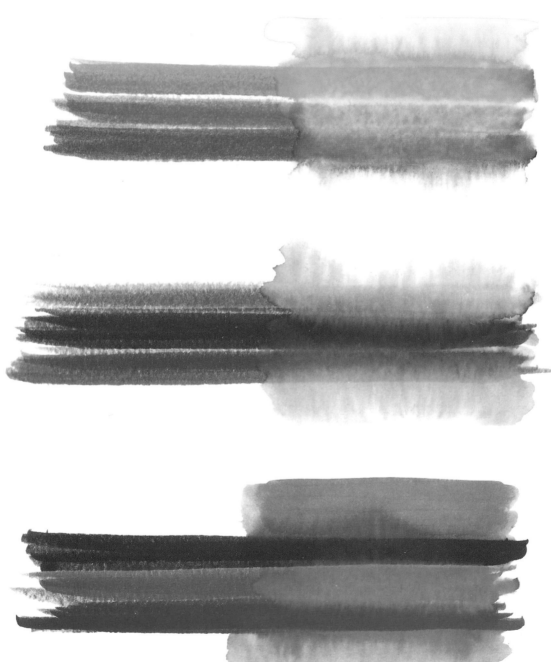

Using brush pens with water

You should always keep one point in mind at all times when combining water with colours, and that is that artwork can very quickly deteriorate into a muddy mess! So to retain freshness, keep your brushwork to a minimum. Once you have made a mark, stop yourself returning to it to make adjustments. When adding water, allow colours to mix and merge on the paper. You can help this along by tipping the board backwards and forwards to encourage colours to run in the right direction.

Some watercolour techniques, though, will not work. For example, 'lifting out', where you rub an area of paintwork with a wet brush and then dab it with a tissue to remove paint and reveal the white of the paper, will be ineffective, as the brush-pen colours stain the paper.

On the opposite page, to give you some idea of how the colours mix on paper, I have painted some bars of colour and brushed half the length with water. You can see that colours soften and blend together. The most striking effects are created with the stronger colours; pale tones can sometimes be a bit disappointing.

The demonstrations below uses the colours more imaginatively. In the first one, reds, blues, yellows and greens have been combined to give some interesting hues. I then brushed water over them and allowed it to run. In this case the colours nearly ran to mud, and I am sure they would have done so had I started working into the picture with my brush.

The second demonstration is made from blue, yellow and green. Again I have allowed the colours to blend together in an unpredictable fashion on the paper.

Two experiments using brush felt-tips with water.

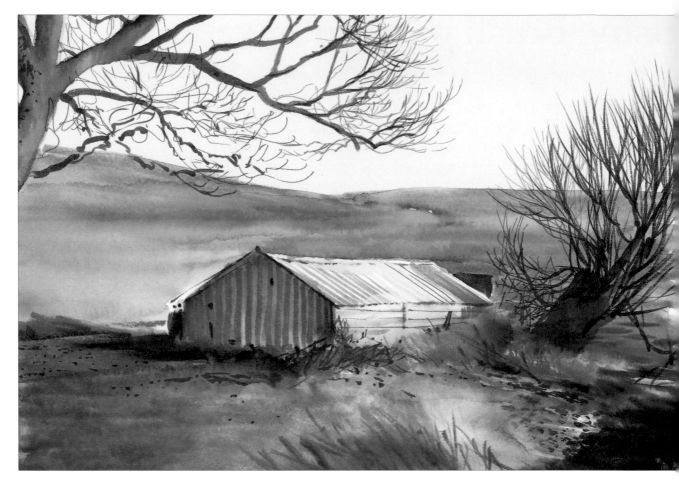

Lakeside hut

I added quite a lot of water to this picture to soften the brush strokes and give an out-of focus quality to the background.

Original size: 215 x 280mm (8¹/₂ x 11in).

Street scene

I brushed the row of houses in the background with water to soften the colours, and the foreground was largely worked in with the side of the brush to give thick grainy strokes.

I usually avoid using black in my paintings, preferring to create dark tones by mixing colours on the paper, such as dark brown and blue. Black can have a very dulling effect on colours, particularly when you add water to produce fluid effects. Here I have used black in the foreground because of the near-silhouette impression produced by the reflected light from the street. I did not use any water in the foreground, to retain a slightly grainy quality to the line work, but I added water to the figures to soften the features.

Original size: 330 x 230mm (13 x 9in).

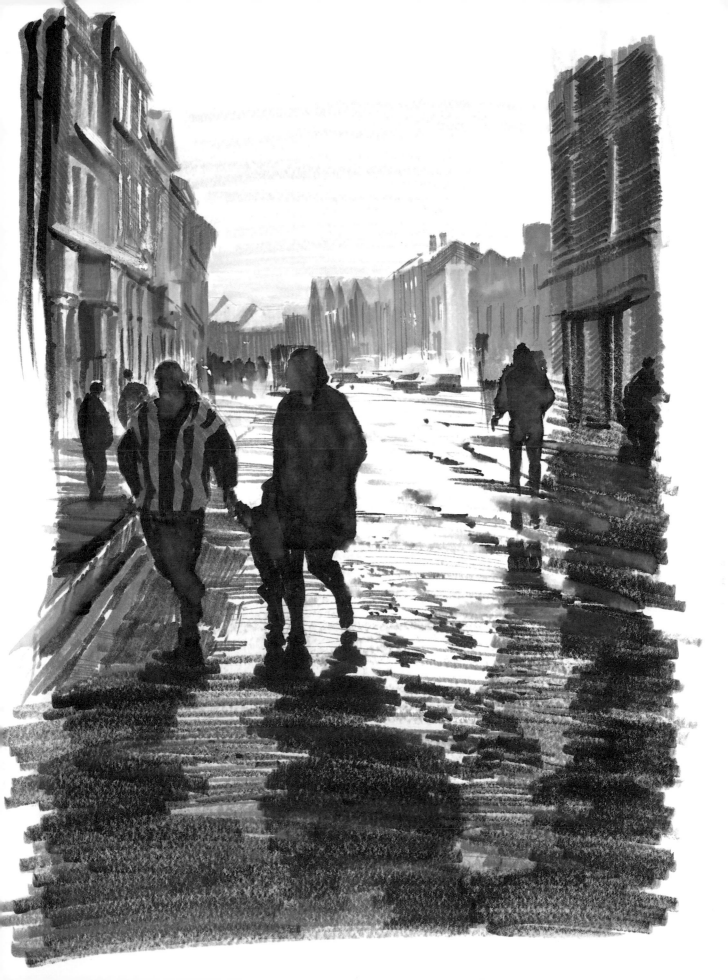

Masking techniques

There are a number of ways you can mask out parts of a picture. Each works differently and can be chosen for a particular effect.

Usually we mask out to avoid obliterating details as we undertake some vigorous brushwork or pen work, but masking can also be used to add texture or highlights to a picture.

Masking fluid

Masking fluid is a liquid which, when you paint it on to the surface of the paper, turns to a latex skin, creating a barrier to waters and inks. It is more commonly used with watercolour paints but can work equally well with brush pens. When the artwork has dried, you can rub the masking fluid away with a finger or eraser.

There is a danger of lifting the masking fluid from the paper if the brush pens are brushed too vigorously over the surface, and you should also check that the paper is strong enough to take masking fluid. Some papers will tear up when the masking fluid is removed.

Masking tape

There are a number of adhesive papers and tapes that you can cut to shape to form a mask. This can be a good idea for blanking out large areas. The

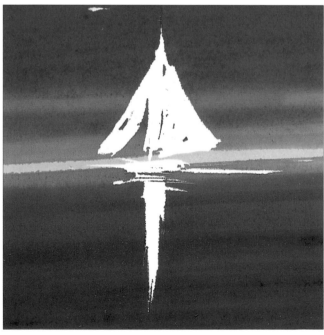

Masking fluid.

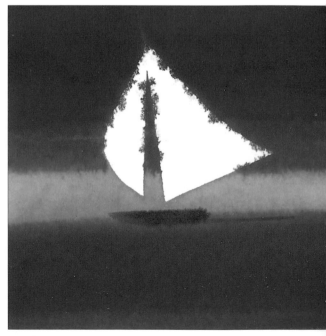

Masking tape.

danger here is of inks bleeding under the edge, especially where very wet techniques are being used.

Wax

Wax is a useful masking technique. As you can see from the example I have given, it gives an impressive broken effect which is more useful for imparting textures and the random sprinkling of highlights than marking out precise areas.

Using this technique, plan out in the initial drawing the areas where these textures will be required and then rub candlewax on to them. Some experimenting is required to work out the potential of this technique and the results can vary depending on the type of paper used.

Bleach

This is not strictly speaking a masking method, but the results are similar. Dyes can be affected by bleach, so you can use it to introduce highlights to a piece of finished artwork by painting it on (see the picture on page 3). Again, this is a slightly imprecise technique and you will find that some colours will bleach out better than others.

The bleach I have used in my example is contained in a household cleaner, and is in a very dilute form. Strong bleach may damage the surface of the paper.

Wax.

Bleach.

Garden flowers

In this painting I wanted to retain the detail of the petals while at the same time working in the very loose background. The mix of detailed work contrasting with uncontrolled wet colours and the vibrancy of the colours makes for an interesting picture.

First of all, I drew the flower heads, paying a lot of attention to the petals. I then painted them out with masking fluid, using an old brush as it tends to clog up the hairs. You can also see other spots and lines across the painting where I have casually flicked and dragged the fluid on to the paper to give a speckling of highlights.

The masking fluid dries quite quickly, so you can start work on the background almost immediately.

I brushed greens and blues on to the watercolour paper and then brushed over them with water, making the colours run. When the background colours were dry, I rubbed away the masking fluid to reveal the white paper beneath.

Next, I introduced the flower-heads, starting with very pale yellows and following with strong yellows to give variation in tone and colour. I gave the centre of the flower-heads some shape by brushing in colours and then softening them by adding water. This emphasises the roundness of the shapes.

Original size: 240 x 315mm (9$\frac{1}{2}$ x 12$\frac{1}{2}$in).

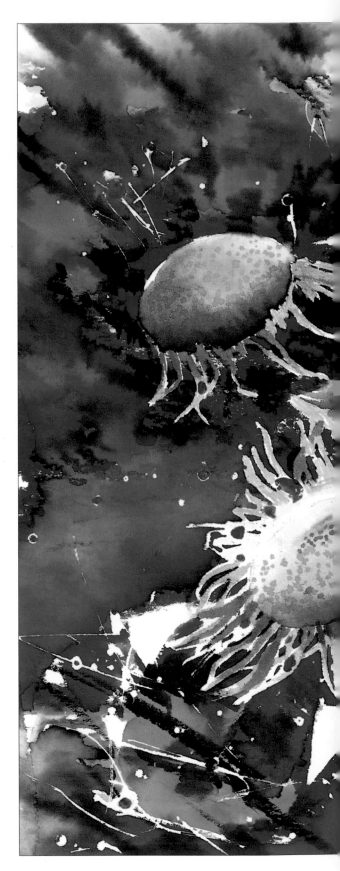

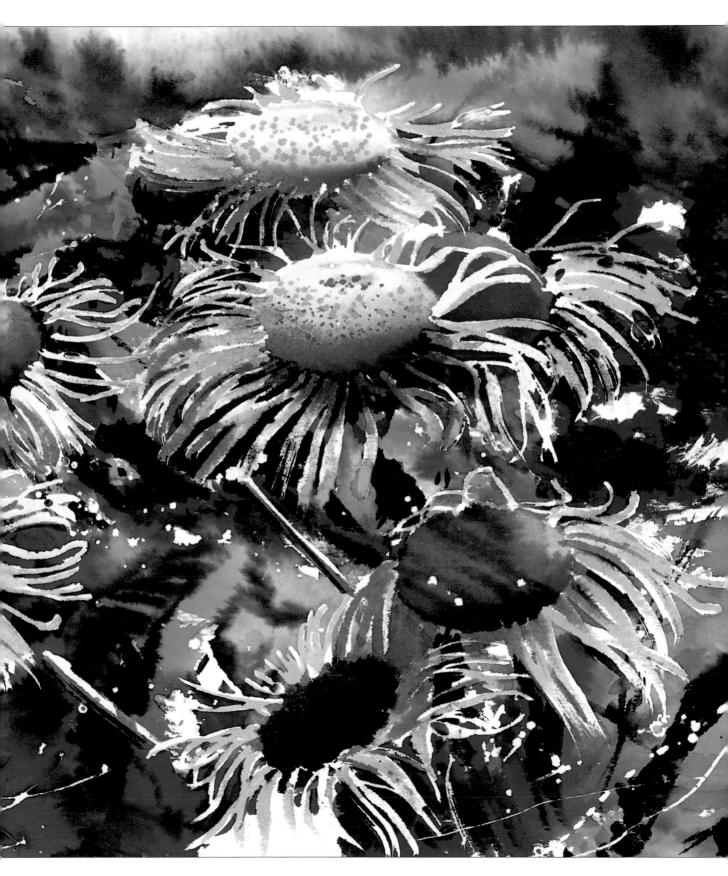

Trying different methods and techniques

There are many different ways of working, and here I have painted some examples, each of which has been treated in a slightly different way.

Irish farmhouse

The sky in this picture is made up of a multitude of fine parallel grey lines drawn with the fine tip of the pen and a ruler for a completely different look. I hatched the landscape in the background with diagonal lines in mid green, some of which I have softened with water and a brush.

Original size: 190 x 265mm (7¹/₂ x 10¹/₂in).

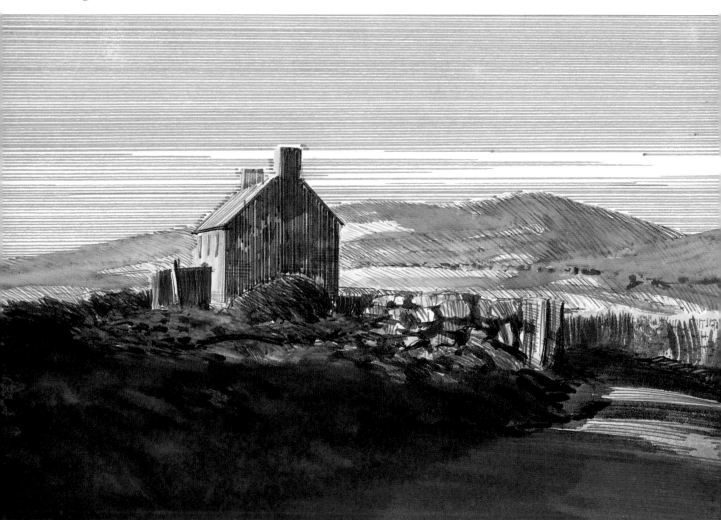

Seated hen

In this study of a seated hen, I applied the colours in quite a 'worked' fashion, colours overlaying colours in an attempt to capture some of the subtle tones in the coat of the bird. There is no exciting design to go on here, just the pleasing patina of the feathers as colours blend together.

I have added some finer detail around the head, where wispy orange feathers give some stronger colouring.

Original size: 125 x 125mm (5 x 5in).

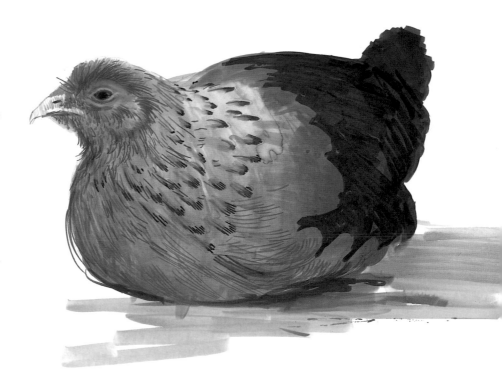

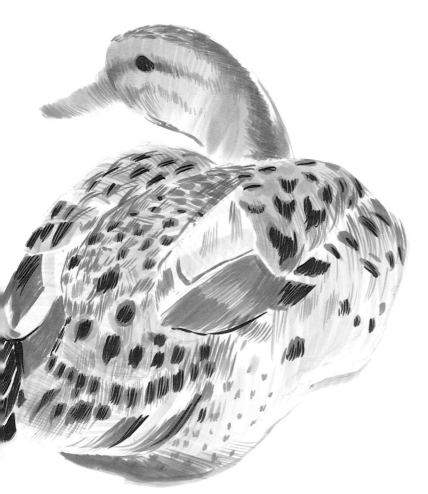

Duck

In contrast, this drawing of a duck is a lot less worked, relying strongly on the white of the paper as part of the colour scheme. I used a little water around the head to soften colours, and the beak provides a welcome point of bright colour. The speckled pattern on the coat of the bird is the point of greatest con-centration, heightened by the avoidance of giving the bird an outline.

Original size: 125 x 125mm (5 x 5in).

21

Profile of hen

A much broader approach has been employed here to paint the profile of a hen. First of all, I swept the broad tip of the brush pen up and down the paper to block in the bright orange of the bird's plumage. I then touched in the bird's wattle with masking fluid to retain the speckle of highlights in this area and to enable me to block in the colour swiftly.

Next, I dashed in reflected colours of bright green on the flanks of the plumage, giving some description to this area of the feathers.

The vigorous technique goes well with the character of the bird, its bright colouring and its intense expression.

Original size: 175 x 150mm (7 x 6in).

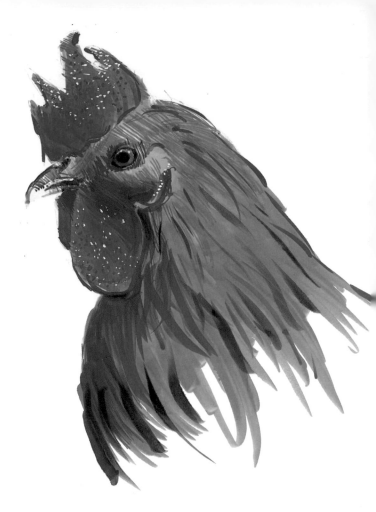

Giant hogweed

The giant hogweed is a huge plant, towering over the tallest figure, and makes a fine subject to draw. It is also very poisonous, so treat it with care. This drawing is made in a more deliberate style, using the fine tip of the pen to build up the pattern of its structure. I drew it first in pencil as a guideline to working in colour.

There is a warm yellow glow cast across the plant by the setting sun, which I have reproduced in the drawing by using yellow. Much of the plant has been drawn in this colour, with occasional deeper tones of tan. Over the yellow I worked a grey, blocking in the shaded areas, the two colours combining to give a pleasant green-grey. Darker areas at the base of the flower heads and at the centre of the plant were coloured with brown.

The background to the plant is a field of corn, again using warm yellow and light brown. In the foreground the colours become darker and here I have used a different brown.

A good range of greens is available, and it is possible to select suitably subdued hues. At the base of the plant I have used three different dark greens.

Original size: 390 x 290mm (15¹/- × 11¹/₂in).

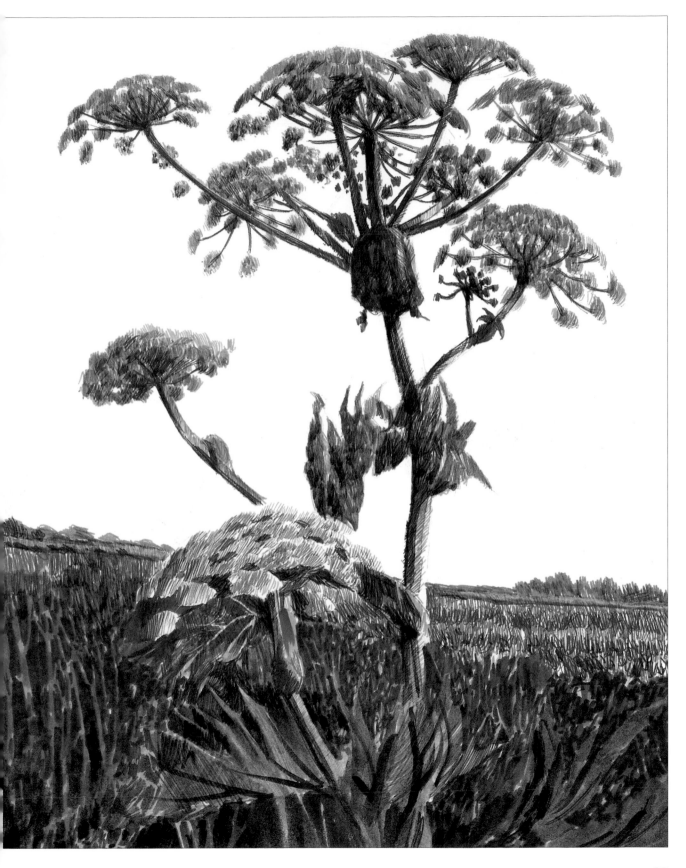

Colour intensity

A real advantage of brush pens is the vividness of their colours. You can get vibrant, intense reds, yellows and oranges, ideal for capturing those bright Mediterranean hues. Watercolour paints can sometimes be a bit disappointing when a really bright colour is required; for example, when you are painting some of the bright colours of flowers, the colours look fine while wet, but on drying lose their intensity. Not so with brush pens; the colours retain their brilliance on drying.

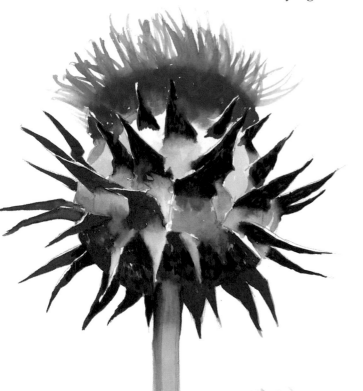

Cardoons

In this picture of flower-heads coming into bloom you can see the clarity of the colours obtainable in brush pens.

Here I have brushed the colours with water to obtain a roundness of form and a soft blending of colours. This, combined with the strong design of the flower-heads, makes for an interesting study.

Original size: 290 x 200mm (11¹/₂ x 8in).

Spanish window

This Spanish window is alive with colour. Splashes of yellows, reds and greens vie to give a sensation of bright sunlight and dazzling Mediterranean colour. There is a large section of wall in shadow, which I painted by brushing the colours together with water. This shows how easily the colours can be turned to muddy hues – only in this case it does not matter as the dark section works as a foil for the brighter colours.

Original size: 355 x 255mm (14 x 10in).

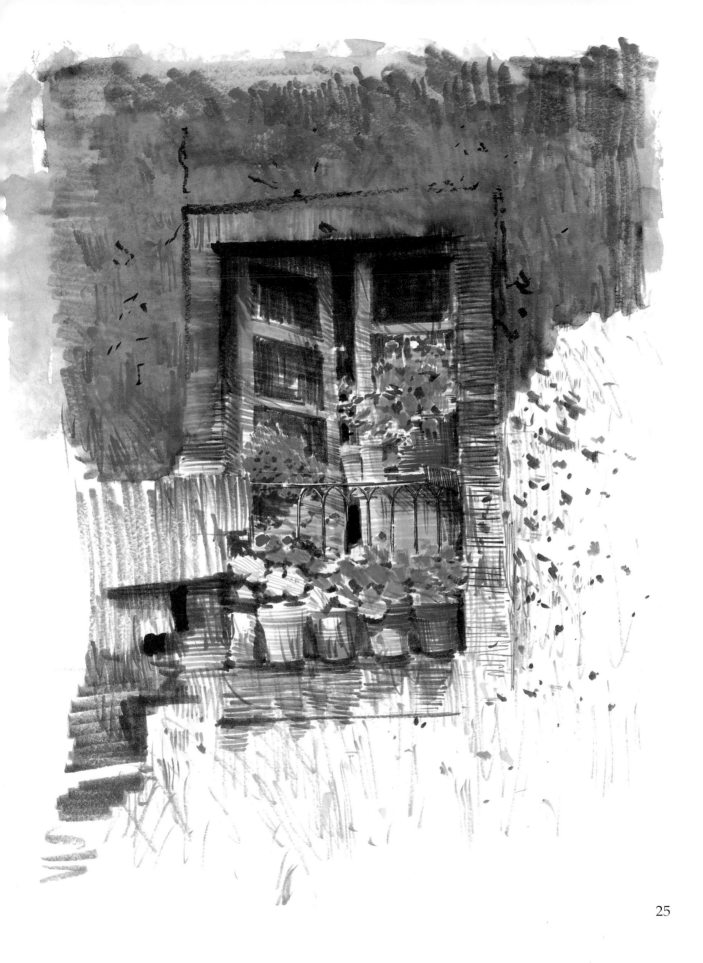

Step by step: *Waterlily*

1. First of all, I drew pencil guidelines for the picture. I then applied masking fluid with a brush where I wished to have highlights around the edges of the petals so that I could work freely up to them without fussing.

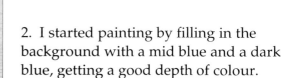

2. I started painting by filling in the background with a mid blue and a dark blue, getting a good depth of colour.

3. Working from light to dark, I began to block in the leaves, first with a bright yellow, then a bright green, and then a couple of darker greens. I softened and blended the colours with a wet brush for a subtle look.

26

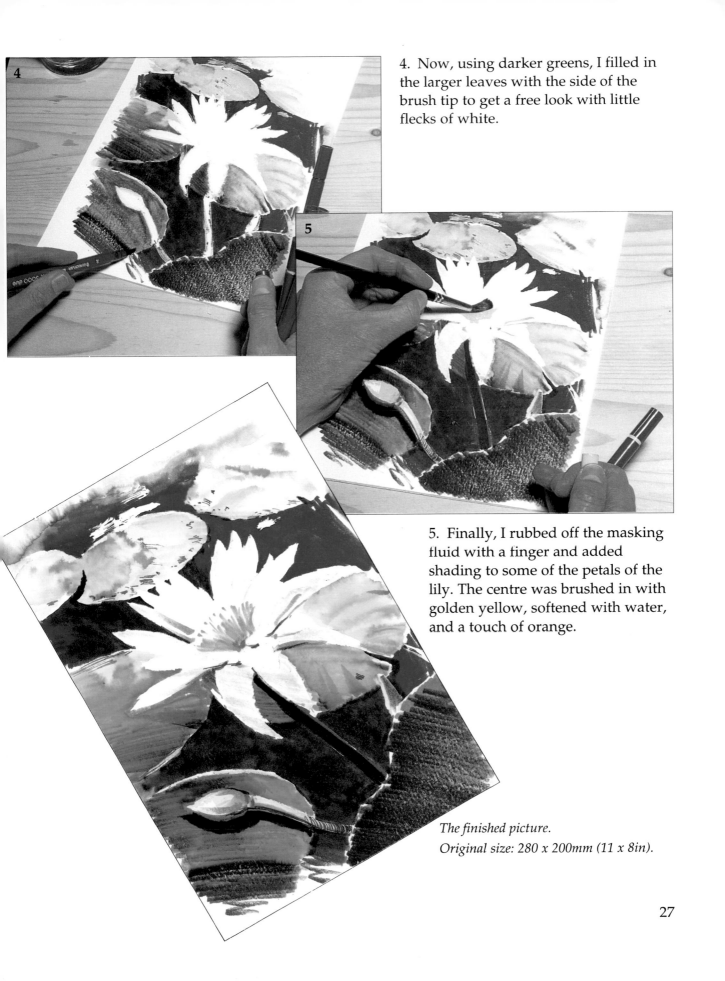

4. Now, using darker greens, I filled in the larger leaves with the side of the brush tip to get a free look with little flecks of white.

5. Finally, I rubbed off the masking fluid with a finger and added shading to some of the petals of the lily. The centre was brushed in with golden yellow, softened with water, and a touch of orange.

The finished picture.
Original size: 280 x 200mm (11 x 8in).

27

Step by step: *Pollarded willow*

1. I sketched the tree lightly in pencil, painted a tracery of very fine lines of masking fluid over the reeds and trunk, and added texture to the bark by drawing invisible wax-resist lines with a birthday-cake candle. Then, I started to fill in the trunk with pale greys and beiges.

2. I carried on working on the trunk of the tree, adding shadows on the bark with darker greys.

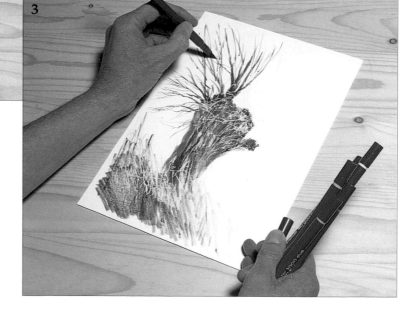

3. Next, I scribbled in dark greys and light brown for the reeds in the foreground and started to draw the branches in a mixture of the same colours.

4. I filled in the rest of the branches and twigs in greys and browns, ensuring that those branches at the back of the tree were drawn in a darker grey.

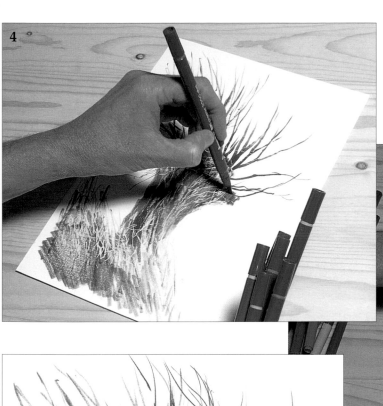

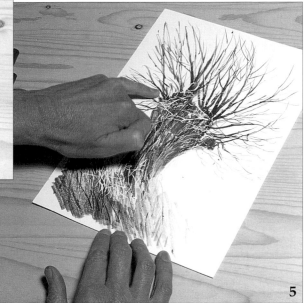

5. Finally, I rubbed off the masking fluid in the reeds and on the trunk, revealing a tracery of white twigs light against the dark tree-trunk.

The finished picture.
Original size: 300 x 200mm (12 x 8in).

Step by step: *Tractor*

1. Having painted a few details on the tractor with masking fluid, I started to block in the background with a mixture of dark grey, purple and green, which I then washed over with a wet brush to blend the colours.

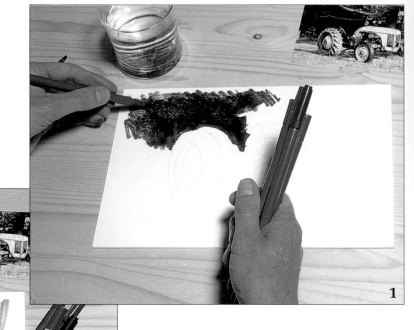

2. Next, I added some warm orange and strokes of purple to the background and blurred these, too, with a wet brush.

3. Quick, broad strokes with the side of a rust-coloured pen tip to suggest long dry grass create a sketchy foreground that will not distract the eye from the focal point – the tractor.

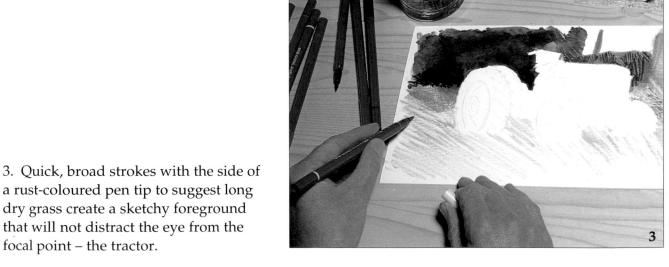

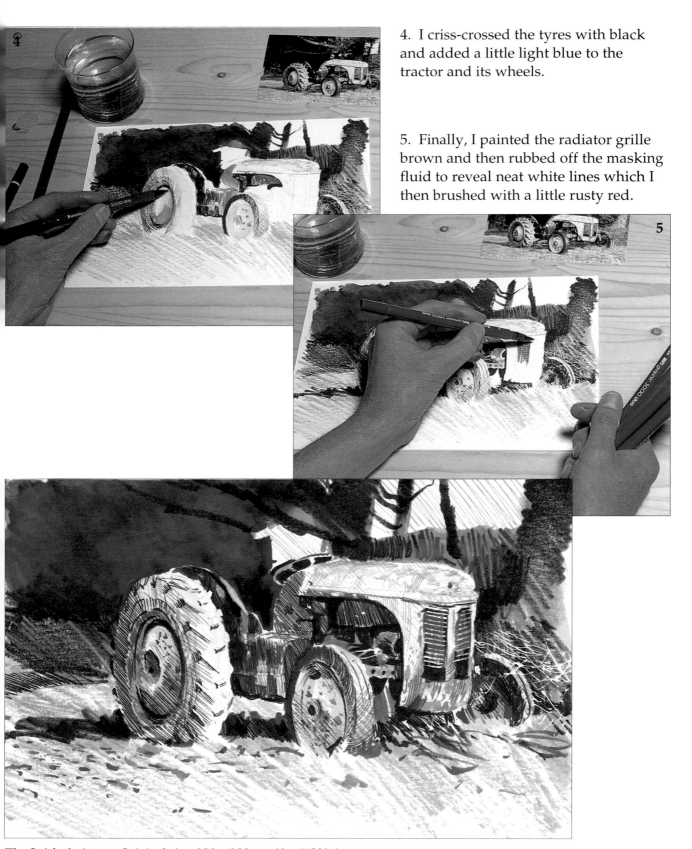

4. I criss-crossed the tyres with black and added a little light blue to the tractor and its wheels.

5. Finally, I painted the radiator grille brown and then rubbed off the masking fluid to reveal neat white lines which I then brushed with a little rusty red.

The finished picture. Original size: 200 x 290mm (8 x 11½in).

Mixed media

It is always interesting to experiment with a medium to discover what new qualities can be found. These days mixed media have become very popular, so all manner of combinations can be tried, including ink, watercolour and pastels.

Watercolour

Watercolours combine well with brush pens. One limitation of the brush pen is the difficulty in obtaining a wash effect for large flat areas of colour, free of brush marks or irregularities. The usual problem area is the sky. A good way round this is to apply a simple watercolour wash for these areas before working with the brush pens.

Pastels

Pastels can be combined freely with brush pens as long as the paper is completely dry before you start rubbing with a stick of colour.

In this picture of three urns, I drew in the urns first with pastels, rubbing the colours into the paper with a finger. I then worked on the top of this with the brush pens, using a dark brown. Finally, I added water to soften the colours and dabbed away the excess with a tissue, obtaining a pleasing speckled surface to the pottery

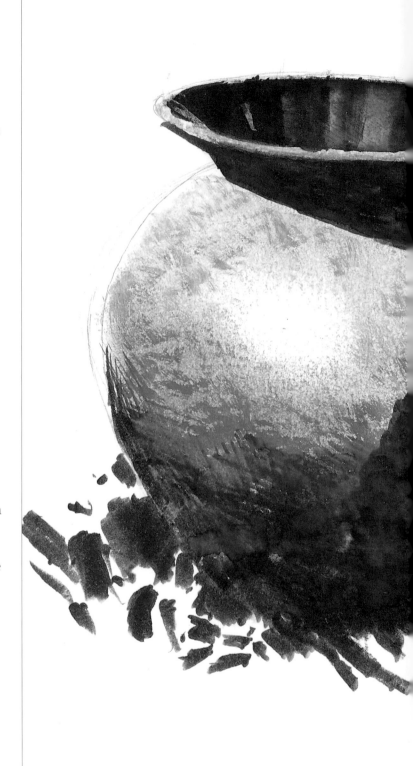

Original size: 255 x 330mm (10 x 13in).

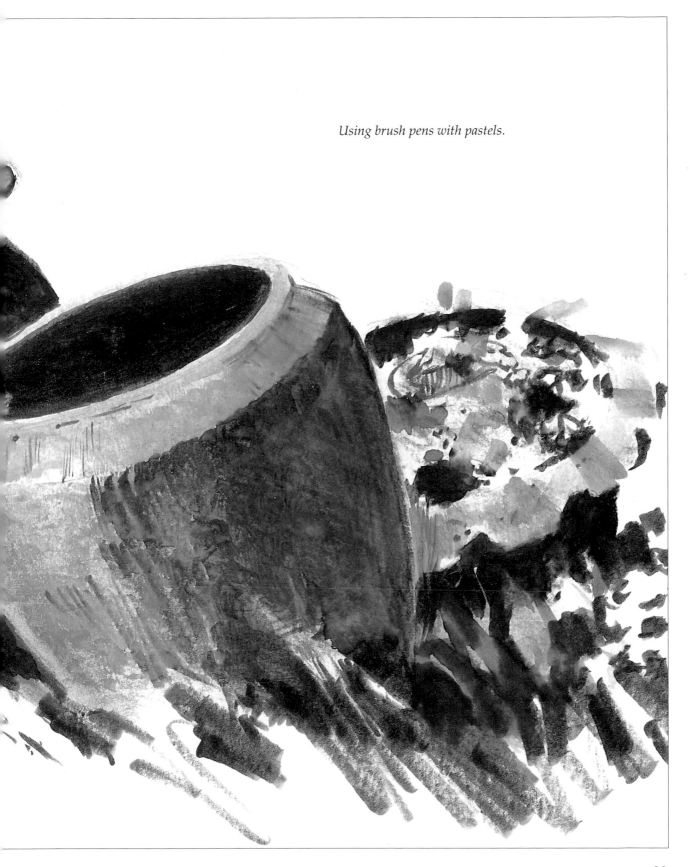

Using brush pens with pastels.

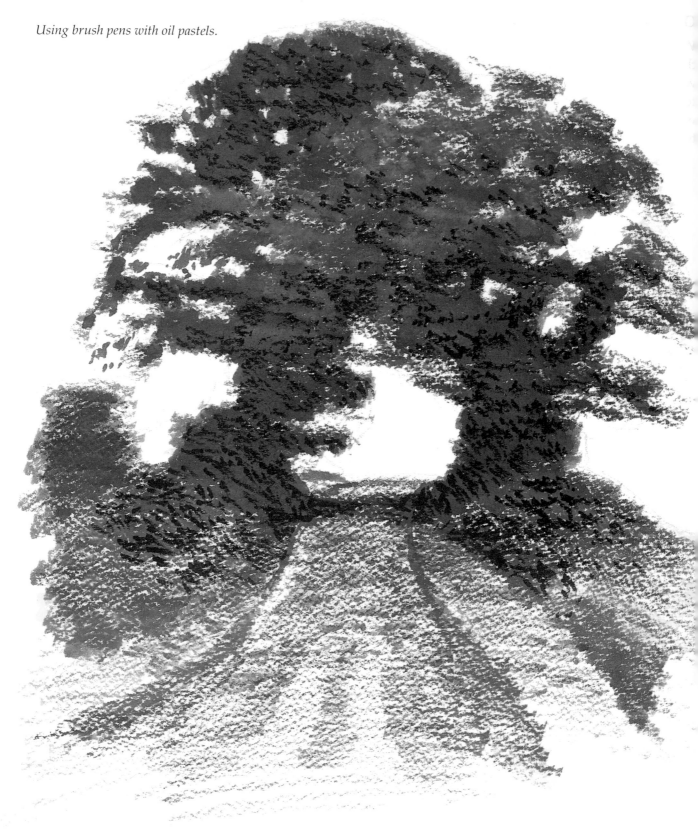

Original size: 255 x 230mm (10 x 9in).

Oil pastels

Wax crayons and oil pastels are another possible mix of media. Here I used the oil pastels first to draw in the base colours and then worked over this with the brush pens, adding water to make the colours run. I was expecting to have difficulty with this combination, as I thought the oil pastels would work as a resist and that I would not be able to use the brush pens over the top of them. However, I had no difficulty.

Inks

Inks can also be mixed with brush pens. Here I have used black ink for technical pens. The technique was rather haphazard, using a lot of water to make the colours run, and then introducing the ink while the paper was still wet. The ink tends to coagulate and form blotches which can be used to advantage in the design. I maintained the detail in the stonework and the white of the window frames by masking them out using masking fluid before the painting began.

Using brush pens with inks.

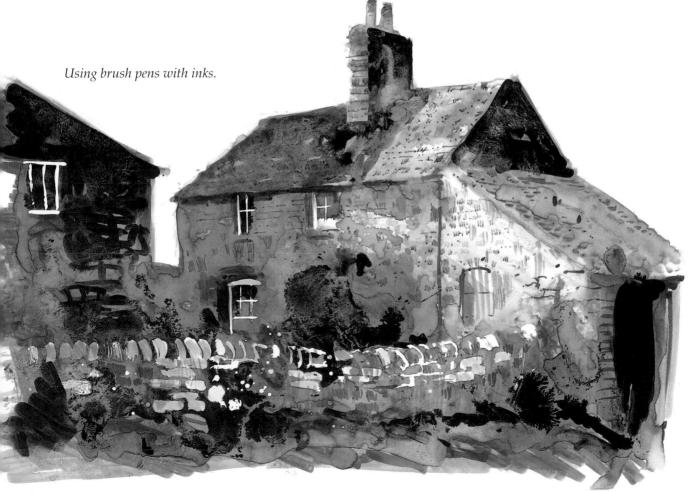

Original size: 265 x 190mm (10¹/₂ x 7¹/₂in).

35

Landscapes

Brush pens are very suitable for landscape work. One can even buy a set of subtle colours especially chosen for painting landscapes.

River at Reefton

The colour of the paper can help in providing the overall tone of a picture. This river scene at Reefton, New Zealand, was drawn on an overcast grey day, so the paper I chose was a grey pastel paper.

My first step was to draw out the scene in a pale grey, just to give a basic outline to the scene. I then progressed to a darker grey to draw in some of the features in the distance, brushing in a bank of conifers on the left with a mix of colours and adding water to soften the overall effect. When this was dry, I again worked over the section to obtain a satisfactory quality. The riverbank on the right is covered with a dense shrub which I have drawn with a mix of mauve and brown overlaying the initial brushstrokes of grey. Again, I added water to soften the colours.

The riverbank on the left is the closest point and the most colourful, with splashes of blues, greens, rusts and black. The deepest colours are in the reflections, which required heavy inking in, followed by dampening with a brush of water to get the depth of colour.

Finally, I added some details in the distance and also some detail to the area of brush in the foreground, using black sparingly to give it prominence.

Original size: 400 x 265mm (16 x 10$^{1}/_{2}$in).

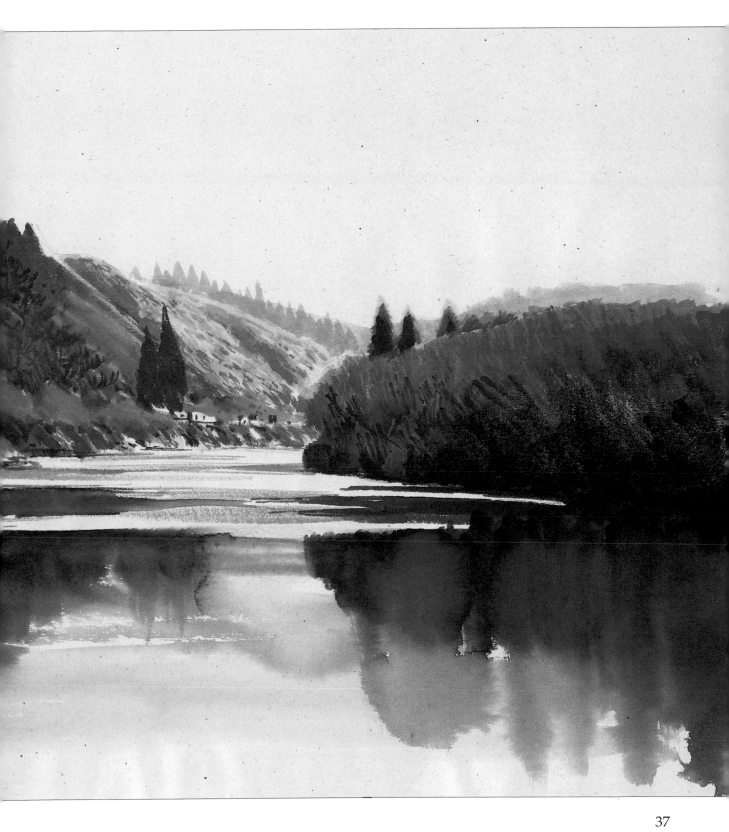

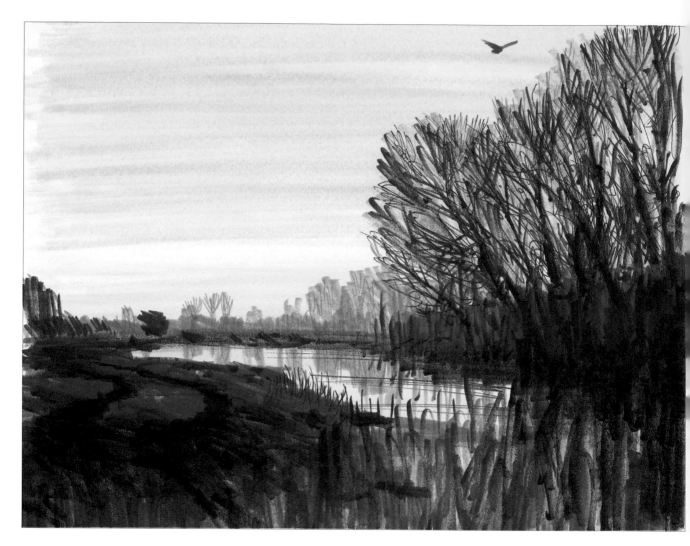

Sunset

This picture shows the evening light over Fenland reed beds. The drawing was made on flesh-coloured card, giving a warm base-tone to work on. I often work on card, which has the advantage of staying flat if I choose to mix water with the brush pens.

In this example I did not use any water with the pens, instead relying on vigorous line work to depict the reeds and the network of branches.

I started with the sky, using the side of the pen to draw long, even lines. To minimise the linear effect I chose a pale blue and made long deft strokes across the board. For a completely flat effect you could resort to watercolours and simply brush in a wash of colour.

The row of trees in the background were coloured with yellow and tan. I then built up the reed beds with a mix of yellow, brown, light brown, Indian red and a little black.

The drawing has mostly been constructed with heavy lines but at the finishing point I scribbled some fine lines into the trees for the maze of

38

branches and a few lines in the reed beds where the reeds are silhouetted against the water. With some ranges of pens, you have the choice of making fine lines either with the brush tip of the pen or with the fine-line tip at the other end. I find that finer lines can be drawn with the brush tip, although this does require quite careful control.

Original size: 340 x 265mm (13¹/₂ x 10¹/₂in).

Shady lane

Brush pens are at their best when used directly to make strong immediate impressions. The flexible drawing tip is very expressive and it is enjoyable to use in this manner.

I drew this view of a high-banked lane in this way, moving the brush around swiftly to describe the branches and undergrowth and using the flexibility of the tip to give character to the line work. I added dark areas of tone by leaning the brush pen on its side to give thick strokes.

A sketch pad and a selection of just a few colours can equip the artist with a versatile set of tools for outdoor sketching.

Original size: 190 x 280mm (7¹/₂ x 11in).

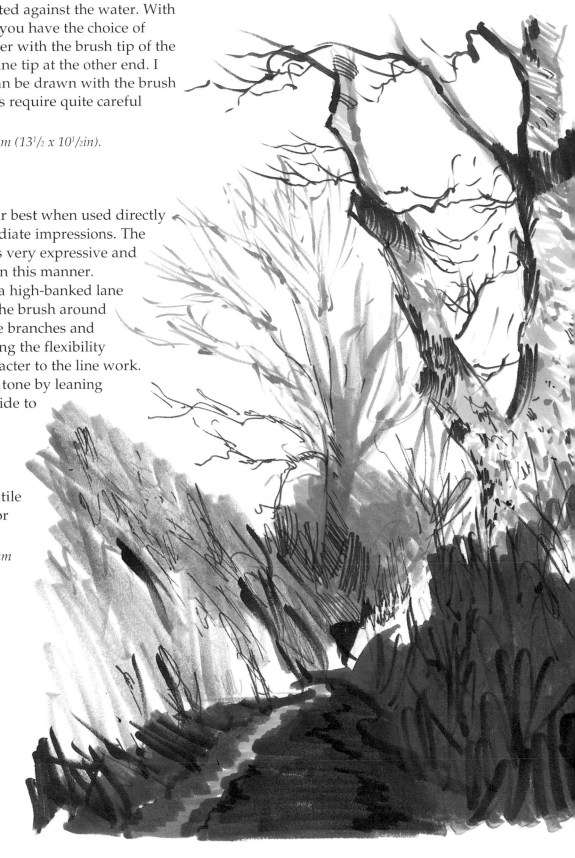

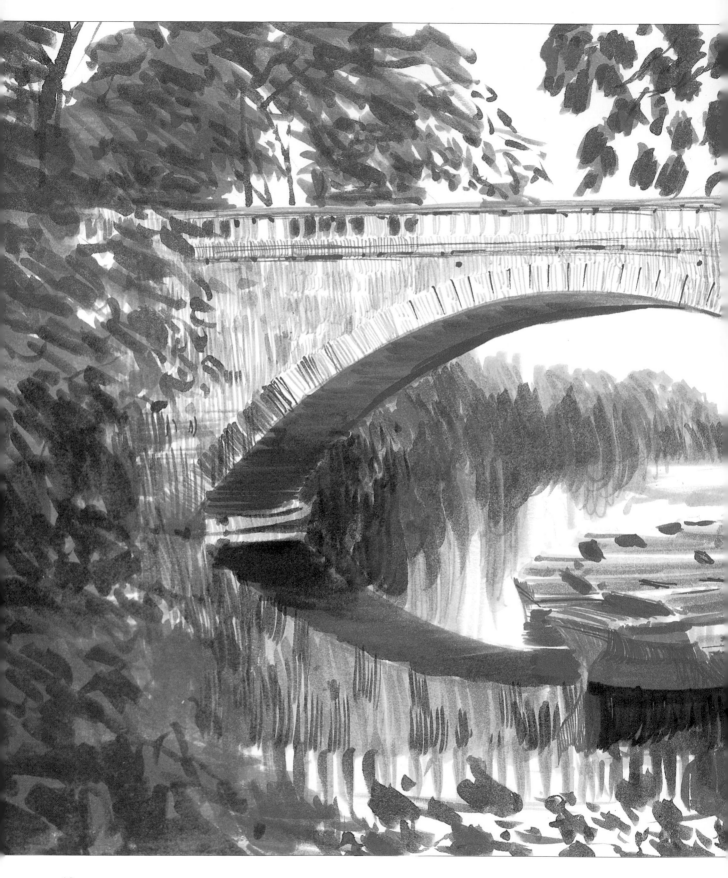

Boats

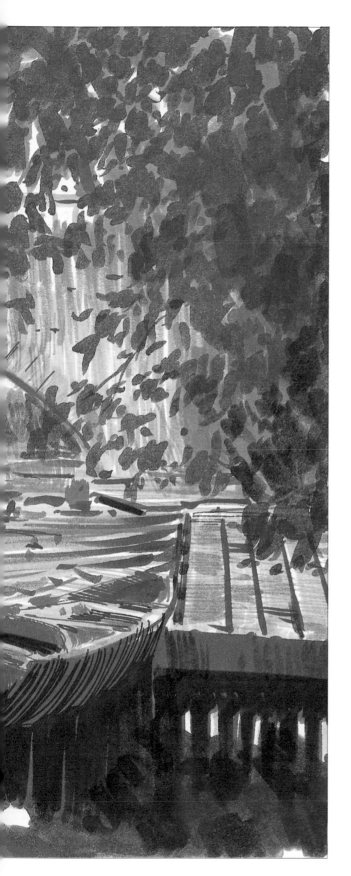

Boats by the bridge

Brush pens are excellent for splashes of bright colour.

In this drawing of a bridge near Warwick Castle, the last rays of the sun are caught on the stern post of a rowing boat and the whole scene is bathed in warm colours.

I dashed the whole scene in with just a little preparatory sketching out with a pencil to ensure that the archway of the bridge was drawn correctly.

First of all, I used one of the lightest colours to block in the main shapes; this was pink. With the basic shapes in place, I felt more confident to use brighter colours, and started colouring the trees in the foreground with two oranges.

I overlaid the pinks in the background with mauves and blue-greys, denoting areas of shade, and then worked the dark areas of foliage in the foreground. Here again I have used mauve and brown, with patches of very dark brown. I have kept all the brushwork lively and responsive, avoiding any tendency to overwork.

I drew the bridge with the fine tip of the pen, picking out stonework and detail using mauve, yellow and a deep red.

The last feature to be added was the boats. The additional colours I used here are a strong blue for the underside of the hulls and a bright red on the stern post, giving a spot of vibrant colour. The red is also echoed here and there amongst the foliage and along the arch of the bridge.

Finally, I used yellow to catch points of light on the bridge and throughout the scene.

Original size: 315 x 215mm (12$\frac{1}{2}$ x 8$\frac{1}{2}$in).

41

Low tide

In this drawing I combined the brush pen with the fine-line tip to give a range of effects from smooth sand to the distressed textured paintwork on the boat.

I used the brush pen mostly to paint the mudflats. Here I carefully drew all the rivulets and puddles and then painted them out using masking fluid, which meant I was then able to paint freely without the added effort of guiding the brush around the detail. First I applied the bright yellows, followed by reds and browns to darken the area of shadow. When I felt I had achieved the right colours, I applied water, which made them merge on the paper and blend into soft flowing shapes suitable for the qualities of sand. When the masking fluid was dry, I removed it and brushed in a pale blue with the fine tip of the brush, reflecting the blue of the sky. Detail in the sand was then introduced with the fine-line tip – patches of seaweed and a little darkening round the edges of the pools.

I also masked out some detail on the boat – the ladder and the rudder. I carried out all the work on this section with the fine-line tip, which enabled me to work slowly to build up the colours and textures. Just occasionally I dabbed a little water into the work where I felt it might add to the effect.

The side of the hull is very weathered, with rust and peeling paint. Here I worked in a large number of colours, introducing them patchily to convey this quality. Finally, I added a couple of paddling figures in the distance to add a little life to the scene.

Original size: 300 x 215mm (12 x 8¹/₂in).

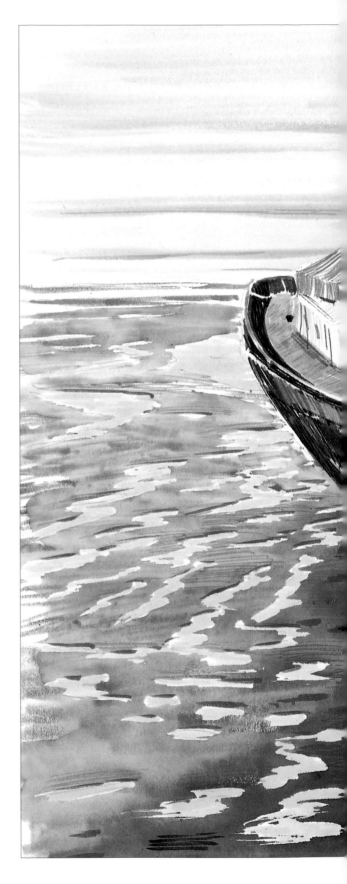

42

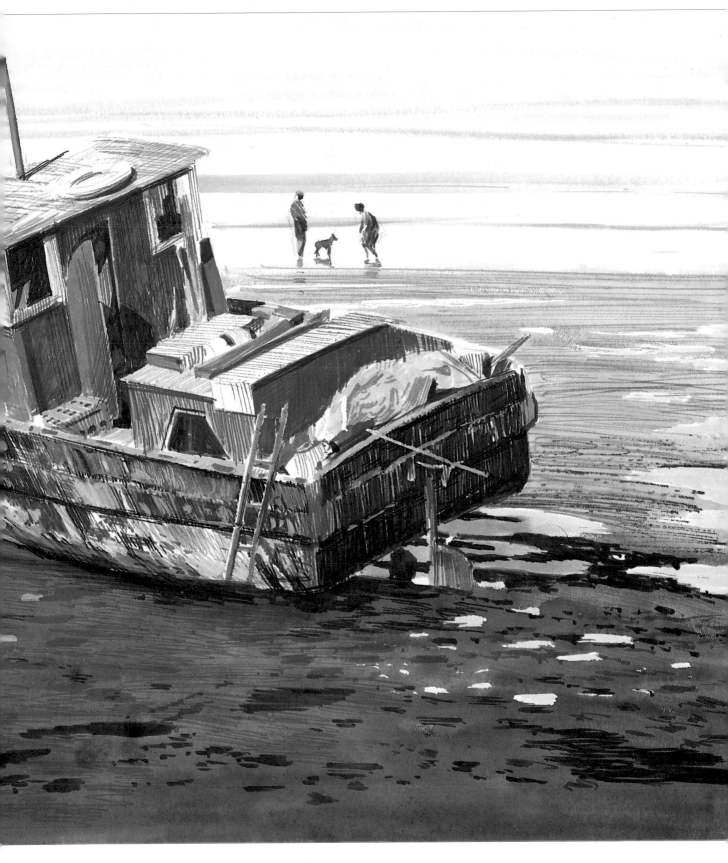

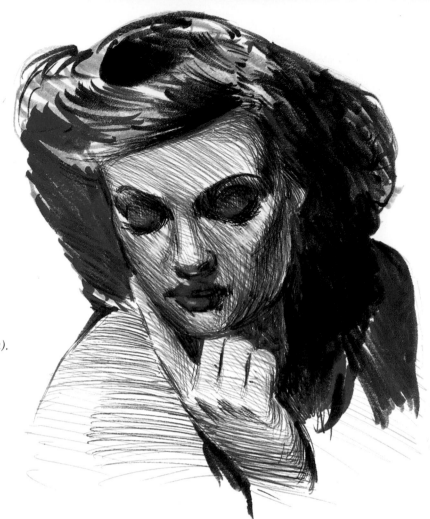

Original size: 150 x 190mm (6 x 7¹/₂in).

Portraits

Figure work is taxing in any medium: the subtle gestures, physical proportions, and the delicate range of flesh tones are all difficult subjects to master. Additionally, we are all good critics of the figure; we all have a heightened awareness and familiarity with the subject, enabling us to spot the most minor of errors, particularly when it is a matter of proportions, such as the size of the head in relation to the body. As regards something less obvious, like weight: does the figure convey any feeling of weight? Does it look as though it is actually resting on its points of support?

In these four drawings I have paid particular attention to the head and shoulders, exploring interesting designs within this area.

1. With the facial features I usually start with the eyes and then hang the rest of the face around these, leaving the hair till last of all. This drawing was lightly drawn in pencil at first, which gives me some freedom when working in colour to concentrate on the tones and shape without continually referring to the figure for every line. The flesh tones have been built up by using the fine-line tip of my brush pens. Starting with yellow, I

44

draw in the tones, avoiding the areas of highlights. These are then followed by blues and reds, gradually building up a subtle range of colours.

The drawing could become rather stiff if I continued working to every corner in this style, so when I reach the areas of heavy colour and tone (the shoulder furthest away from you and the hair), I use broad sweeps of the brush pen to block these areas in. The lively brushwork contrasts pleasantly with the more painstaking work on the face.

A little bit of corrective work was needed on the eyelids and lips to introduce highlights. I did this by using a little water to lift some of the colour away. This technique is not very effective with brush pens but was adequate to lighten these points a shade or two.

2. I have used colour in a more exaggerated way in the flesh tones of this subject, choosing rich blues for the areas of shadow and bright points of colour, and yellows and reds to accentuate curves. Note that I make little use of cross-hatching in my technique, preferring to run lines of colour in approximately the same direction. I prefer to use lines this way, as a grid of line work can become rather dull. Also, lines can be used to give a sense of movement and direction, describing curves and bends. In this drawing, too, I have returned to the thicker edge of the brush pen to describe the hair boldly.

Original size: 290 x 190mm (11$\frac{1}{2}$ x 7$\frac{1}{2}$in).

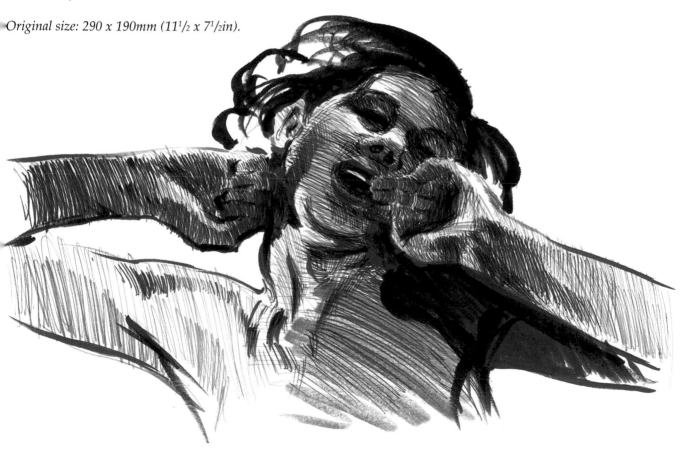

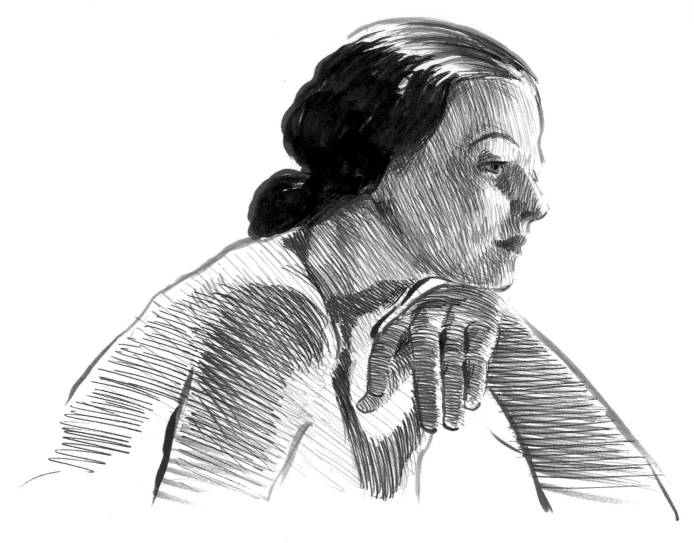

Original size: 230 x 175mm (9 x 7in).

3. I have built up the flesh tones in this drawing using fine and thick lines, taking care not to draw over the points of highlight such as the cheekbone and above the eye.

The outline colours have been helpful in this picture to give it some strength, reds, yellows and blues emphasising areas of warm light or cool shade.

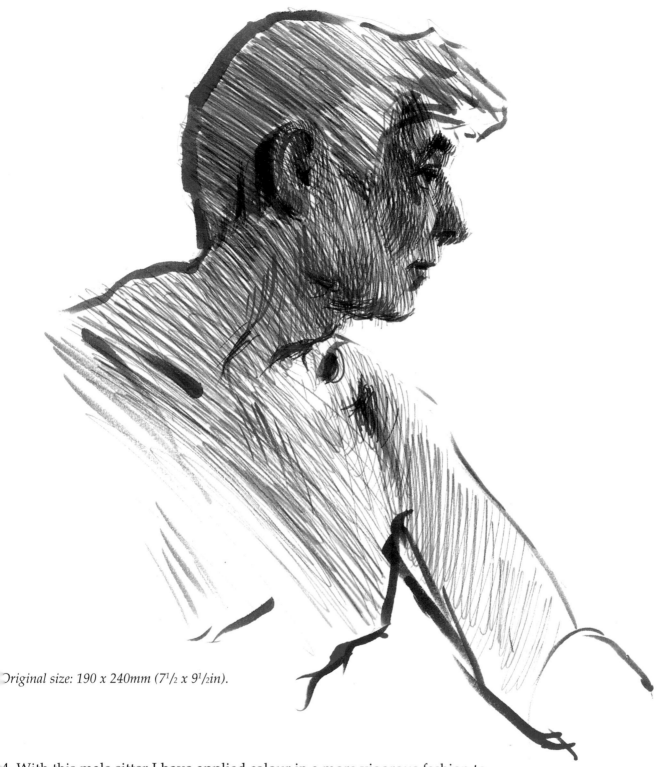

Original size: 190 x 240mm (7¹/₂ x 9¹/₂in).

4. With this male sitter I have applied colour in a more vigorous fashion to convey a more rugged skin texture. The colour range is more varied, too, employing pink, red, yellow ochre and grey-blue. Note how the use of the outline is used to give the drawing dynamism, thick here and thin there, vanishing completely in places.

Index

If you have difficulty in obtaining any of the materials or equipment
mentioned in this book, please write for further information and a constantly
updated list of mail-order stockists to the Publishers.

Search Press Limited,
Wellwood, North Farm Road,
Tunbridge Wells, Kent TN2 3DR, England.

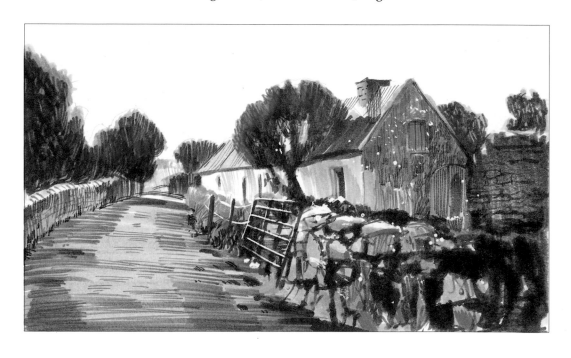